THIS BOOK

Belongs to

www.ingramcontent.com/pod-product-compliance
Lightning Source LLC
Chambersburg PA
CBHW080845170526

45158CB00009B/2641